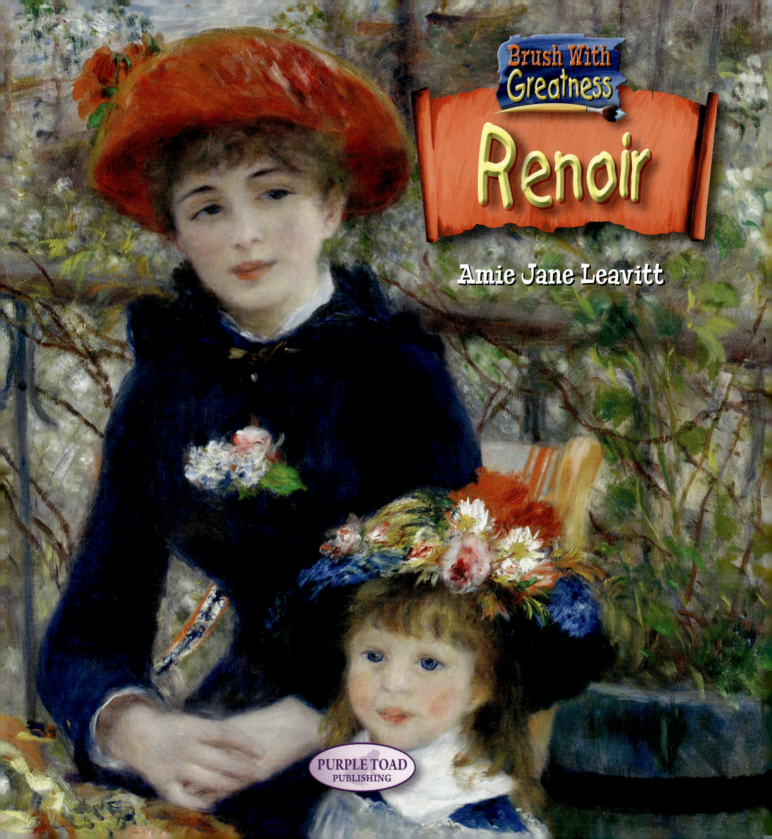

Copyright © 2017 by Purple Toad Publishing, Inc. All rights reserved. No part of this book may be reproduced without written permission from the publisher. Printed and bound in the United States of America.

Printing 1 2 3 4 5 6 7 8 9

Cézanne
Gainsborough
Goya
Leonardo da Vinci
Michelangelo

Monet
Rembrandt
Renoir
Van Gogh
Vermeer

Publisher's Cataloging-in-Publication Data
Leavitt, Amie Jane.
 Renoir / written by Amie Jane Leavitt.
 p. cm.
Includes bibliographic references, glossary, and index.
ISBN 9781624693250
eISBN 9781624693267
1. Renoir, Auguste, 1841-1919—Juvenile literature. 2. Painters—France—Biography—Juvenile literature. I. Series: Brush with greatness.
 ND553.R45 2017
 759.4
Library of Congress Control Number: 2016957441

ABOUT THE AUTHOR: Amie Jane Leavitt graduated from Brigham Young University and is an accomplished author, researcher, and photographer. She has written more than sixty books for kids. To check out a listing of Amie's current projects and published works, visit her website at www.amiejaneleavitt.com.

Previous page: *Two Sisters (On the Terrace)*, 1881

Contents

Chapter 1
Madame Renoir 5

Chapter 2
Mixing Paints 9

Chapter 3
Studying the Masters 13

Chapter 4
Painting a Painter 17

Chapter 5
Home Sweet Home 23

Timeline 28

Selected Works 29

Further Reading 30

Glossary 31

Index 32

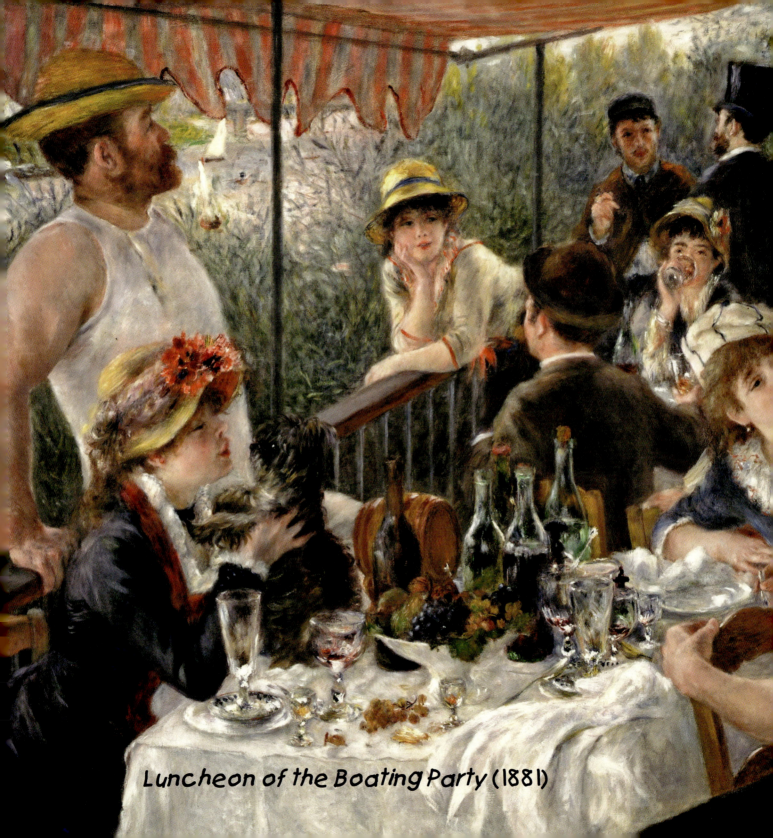
Luncheon of the Boating Party (1881)

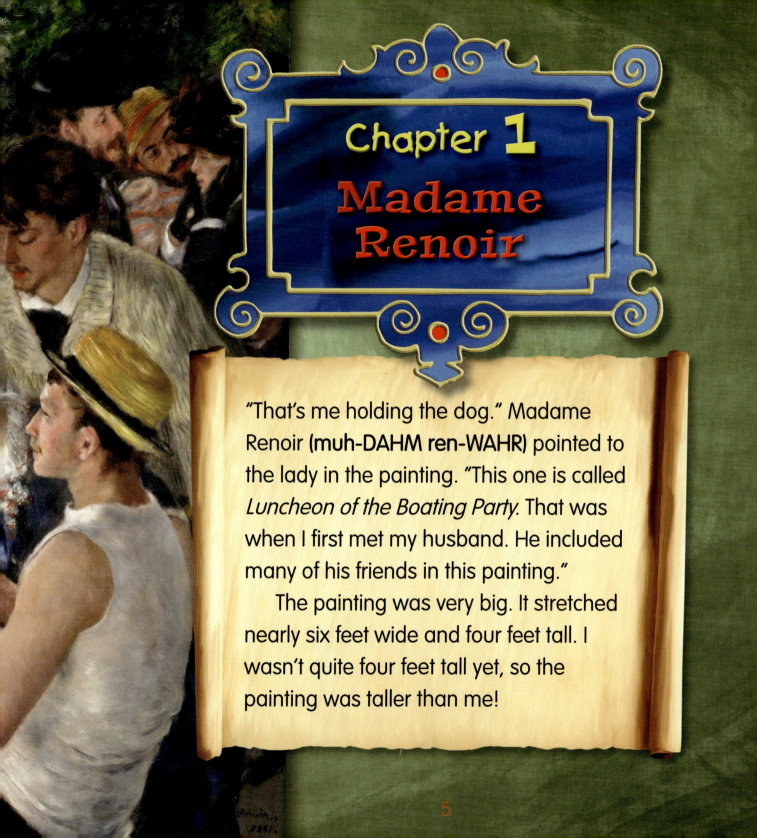

Chapter 1
Madame Renoir

"That's me holding the dog." Madame Renoir **(muh-DAHM ren-WAHR)** pointed to the lady in the painting. "This one is called *Luncheon of the Boating Party.* That was when I first met my husband. He included many of his friends in this painting."

The painting was very big. It stretched nearly six feet wide and four feet tall. I wasn't quite four feet tall yet, so the painting was taller than me!

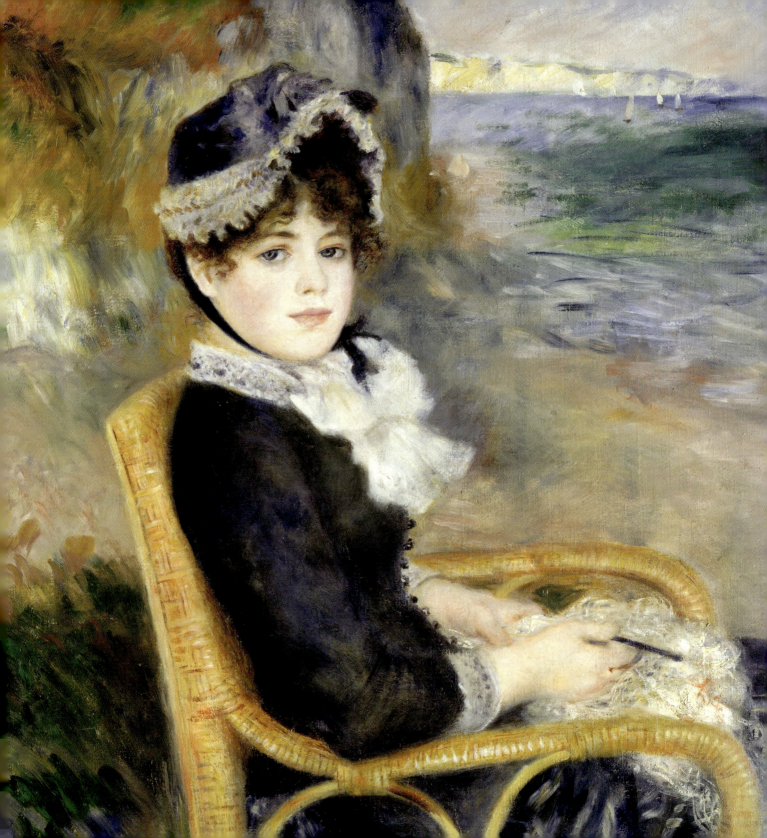

My neighbor, the great artist Renoir, painted it many years before I was born. It was definitely one of my favorites. I enjoyed looking at it every time I went to the Renoir home. I always saw new things in it, just like that day. I hadn't known Madame Renoir was in the painting!

"Is Monsieur [mis-YUR] Renoir in his studio?" I asked, after studying the painting with her for a few minutes.

"Yes, Leo," she replied. "He is waiting for you."

Aline Charigot was a model for some of Renoir's paintings, including *By the Seashore*. She later married him.

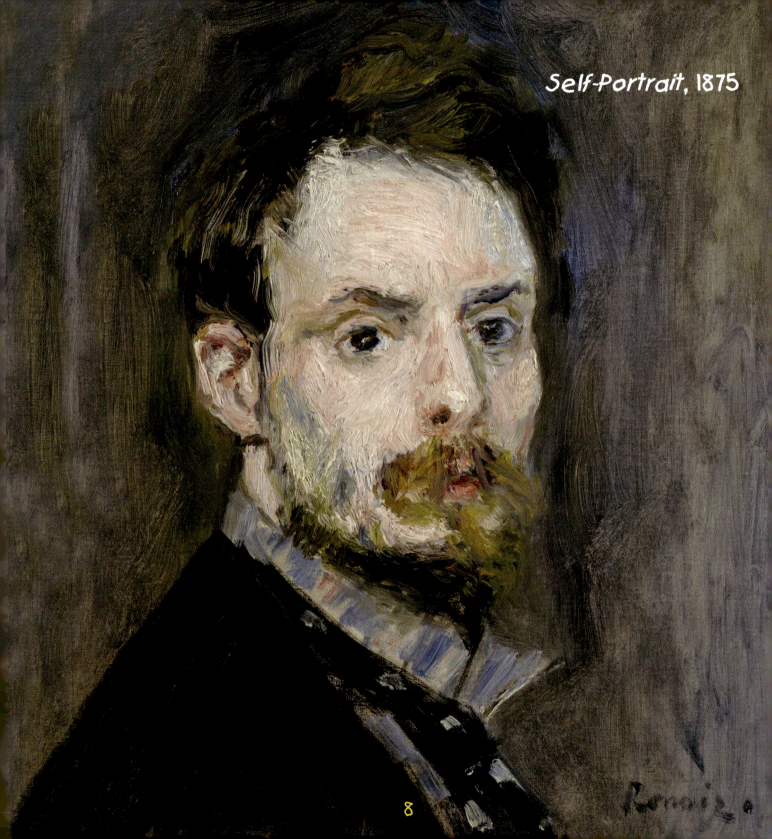
Self-Portrait, 1875

Chapter 2
Mixing Paints

I walked down the hallway toward Renoir's studio. As I entered the room, I saw the great artist sitting in front of one of his latest paintings. I had never seen him out of his wheelchair. He could walk a little, but it was very hard for him. He said he wanted to save his energy for painting.

"Leo, you are here!" he said excitedly. "The paints are on the table. Will you mix them for me and then bring me my brush?"

"Of course, Monsieur," I said as I hurried over to the table. I found his palette **(PAL-it)**, just where I had left it the day before. I put dabs of green, yellow, and blue on the wooden board. I placed the palette and brush on the small table next to Renoir. Then I picked up some long strips of rags.

I held Renoir's crippled hand and placed the brush in his fist. I gently wrapped the strips around his hand. Again and again I wrapped. Finally, the brush was held in place.

"Arthritis **[arth-RY-tis]** is a terrible disease, Leo," Renoir said. "But I'm determined to keep painting no matter what. Thank you for helping me by mixing my paints and tying the brush to my hand."

This was one of the things I liked the most about my neighbor. He never quit, no matter how hard things got. I wanted to be like that, too.

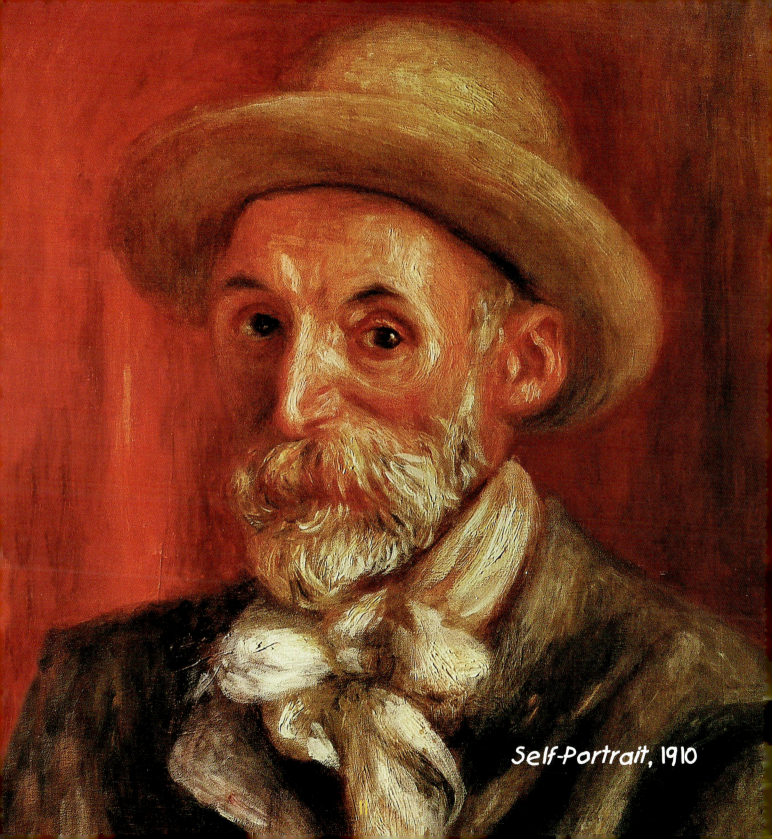
Self-Portrait, 1910

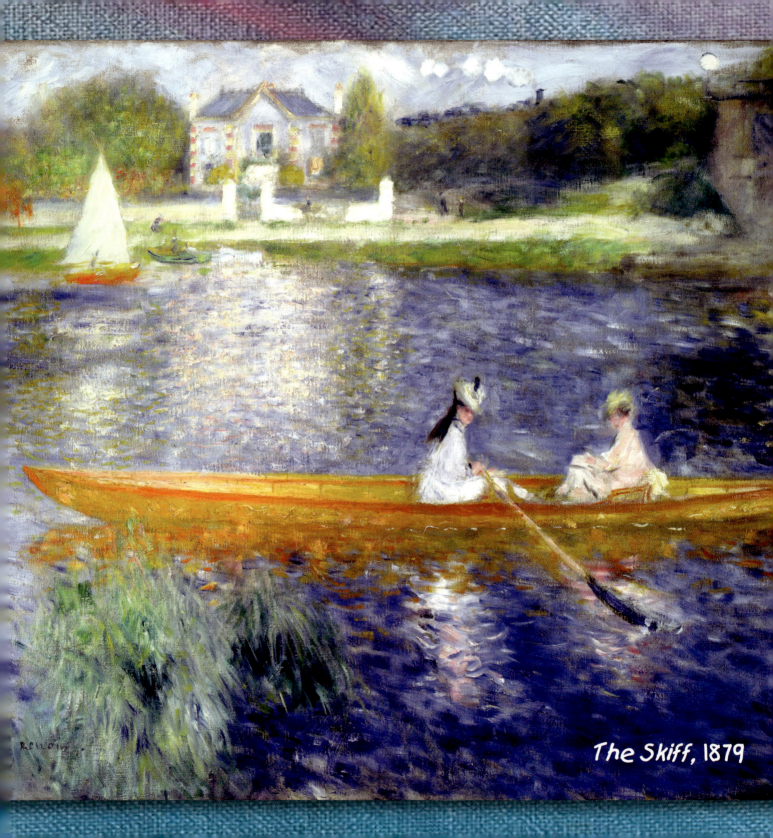
The Skiff, 1879

Chapter 3
Studying the Masters

As Renoir painted in his studio, I walked the halls of his house. I liked looking at the paintings on the walls. As I gazed at each one, I imagined I was painting them myself.

I looked at the bright colors of *The Skiff*. Sunlight sparkled on the lake. The paint colors made it look that way, not real sunlight. There were many different shades of blue in the water. There were also strokes of white, pink, red, and yellow. The orange boat seemed to melt into the blue lake.

"Monsieur Renoir learned to paint by studying other paintings," Madame Renoir said as she came down the hallway. "He spent hours and hours at the Louvre **[LOOV]**. That's an art museum in Paris. He would look at the paintings there. Then he would try to paint his own to look like them."

"Did he begin by painting on glass? I heard someone say that," I said.

"You heard right. My husband did not come from a rich family. When he was thirteen, he went to work. He was the apprentice **(uh-PREN-tis)** to a porcelain **(POR-suh-lin)** painter. He painted pictures on things like dishes and fans. But my husband wanted to do more with his life. He wanted to be a serious artist. That's when he started going to the Louvre to study. He also took some art classes, where he met Monsieur Monet. You remember meeting him when he visited, right?"

"I sure do!" I replied. After all, who wouldn't remember meeting Monsieur Monet? He was a famous artist just like Renoir. How lucky I am! I am so young, but I have already met two of France's best artists.

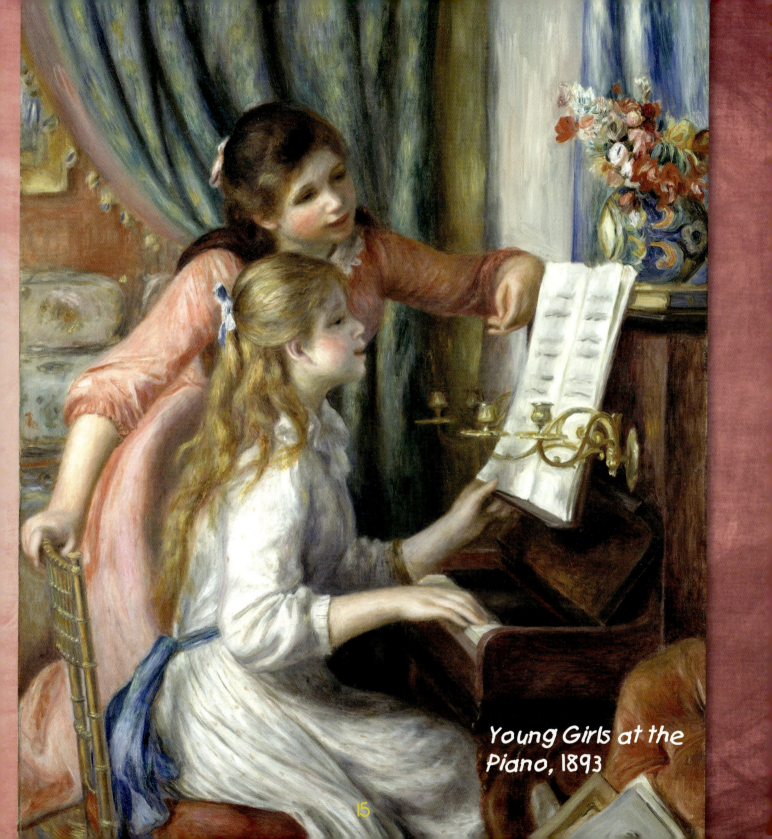
Young Girls at the Piano, 1893

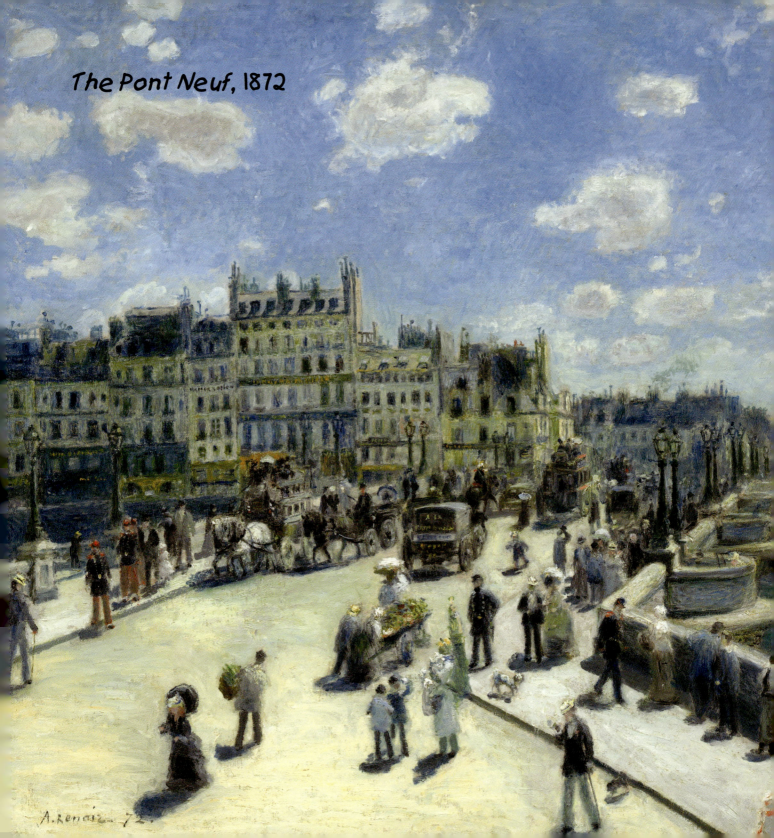
The Pont Neuf, 1872

Chapter 4
Painting a Painter

At lunchtime, Renoir took a break from painting. I untied the brush from his hand and wheeled him into the garden. I set a tray of croissants **(kruh-SAHNTS)**, cheese, and grapes on the table. Madame Renoir joined us. As we ate, Monsieur Renoir talked about the old days.

"I loved living in Paris. It was the perfect place for a young artist. I spent days painting along the Seine **(SEHN)**. That is where Monet and I came up with our style of painting.

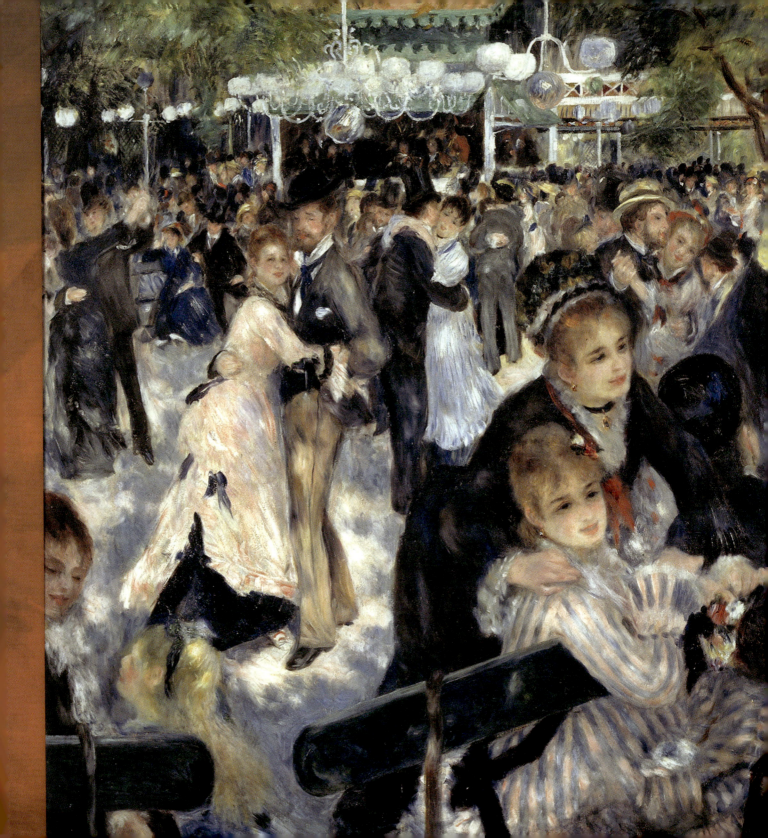

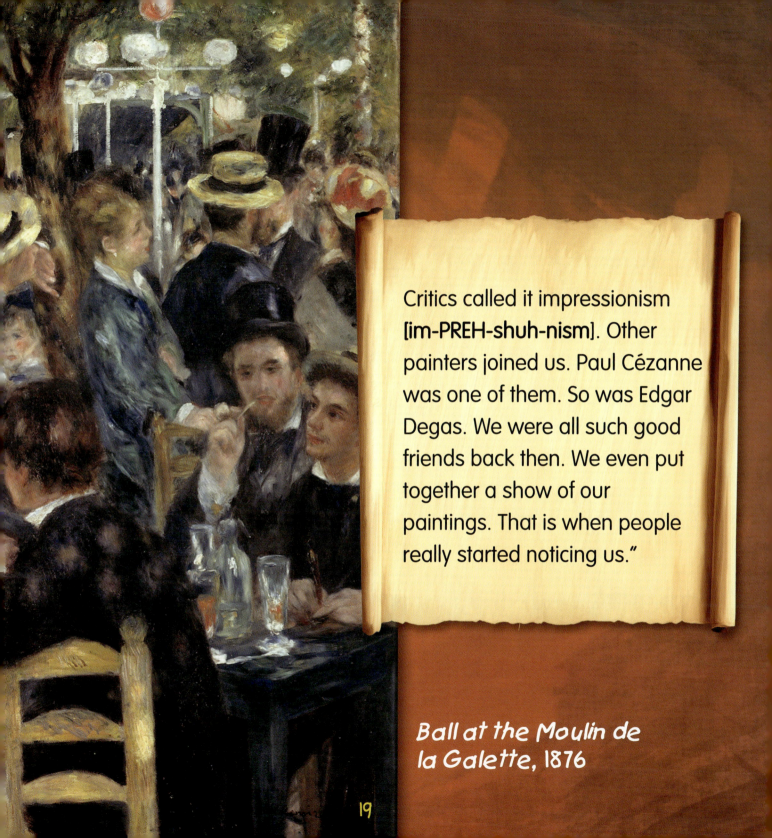

Critics called it impressionism [im-PREH-shuh-nism]. Other painters joined us. Paul Cézanne was one of them. So was Edgar Degas. We were all such good friends back then. We even put together a show of our paintings. That is when people really started noticing us."

Ball at the Moulin de la Galette, 1876

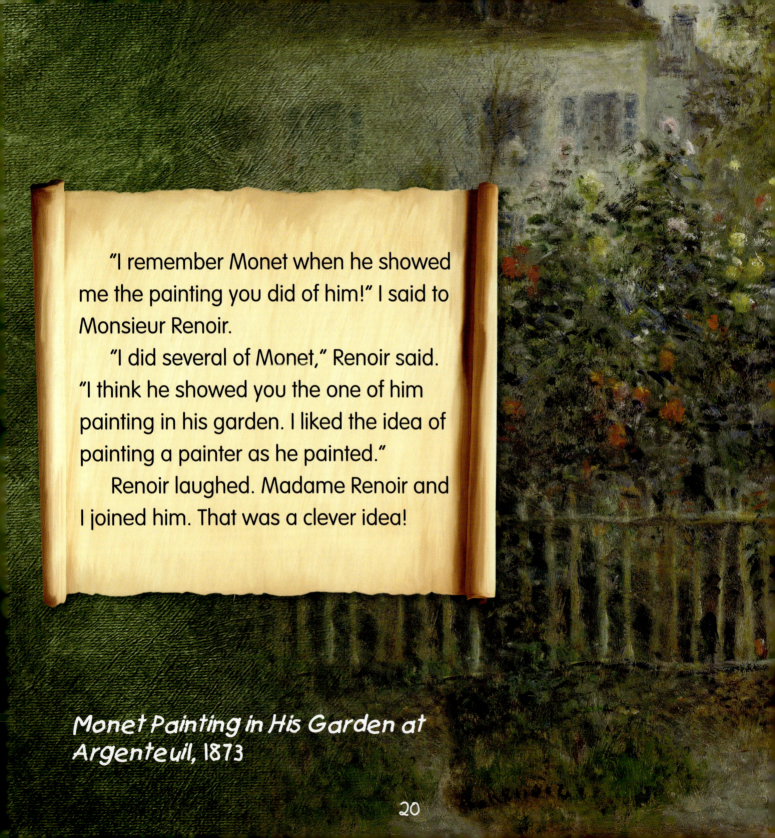

"I remember Monet when he showed me the painting you did of him!" I said to Monsieur Renoir.

"I did several of Monet," Renoir said. "I think he showed you the one of him painting in his garden. I liked the idea of painting a painter as he painted."

Renoir laughed. Madame Renoir and I joined him. That was a clever idea!

Monet Painting in His Garden at Argenteuil, 1873

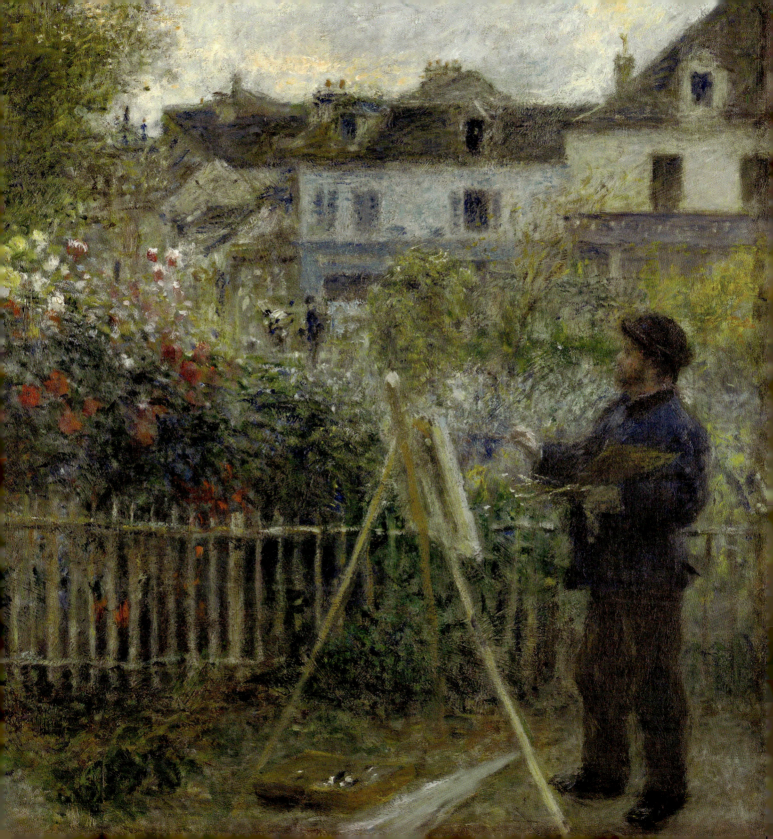

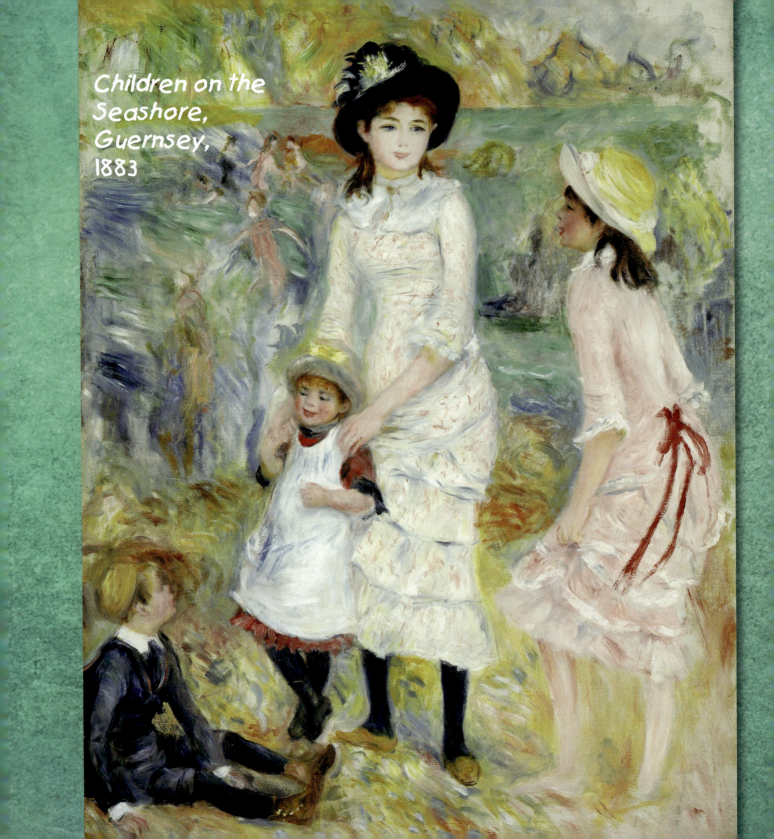
Children on the Seashore, Guernsey, 1883

Chapter 5
Home Sweet Home

The sun was beginning to set. Madame Renoir walked into the studio. "Daylight is fading, my dear," she said to her husband. "You do not want to tire yourself by working too long. Perhaps it is time to call it a day."

Monsieur Renoir agreed. He asked me to remove the brush from his hand. I carefully unwrapped it and placed it on the table. I set the palette next to it. Tomorrow, I would come back, just like I did every day. I would mix the paints. I would tie on the brush. And Renoir would continue to paint on his canvas (KAN-vus).

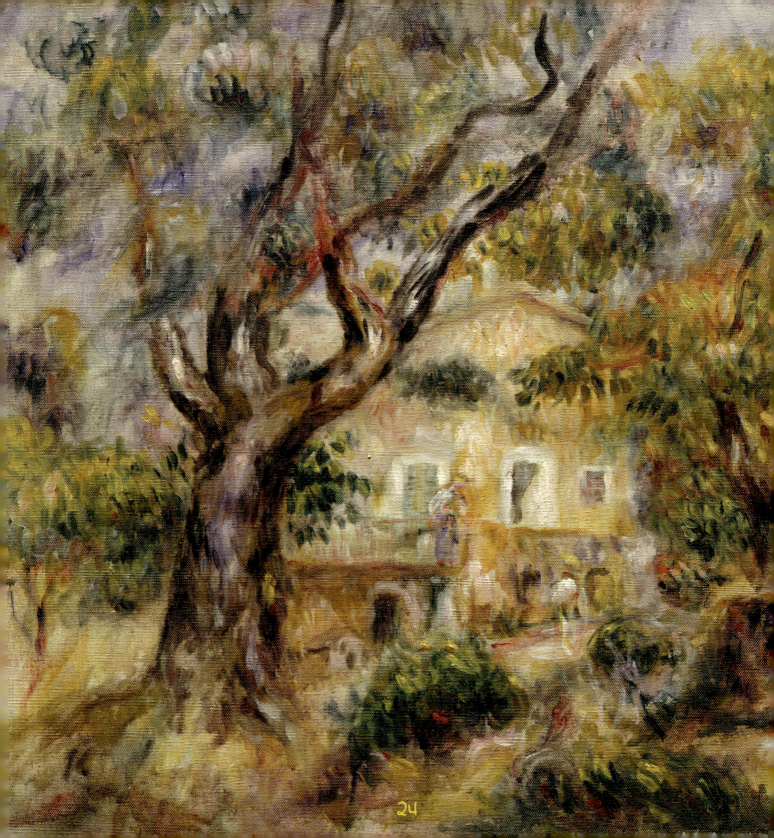

The Farm at Les Collettes, Cagnes (1914) looks like Renoir's home in the South of France.

He was almost finished with his current painting. I stood next to him and looked at the painting on the easel **(EE-zul)**.

"That's your house!" I said with excitement.

"You're absolutely right," Renoir replied. "I'll call this one *The Farm at Les Collettes, Cagnes* **(lay-KOH-lays, CAN-yeh)**. It is my home sweet home."

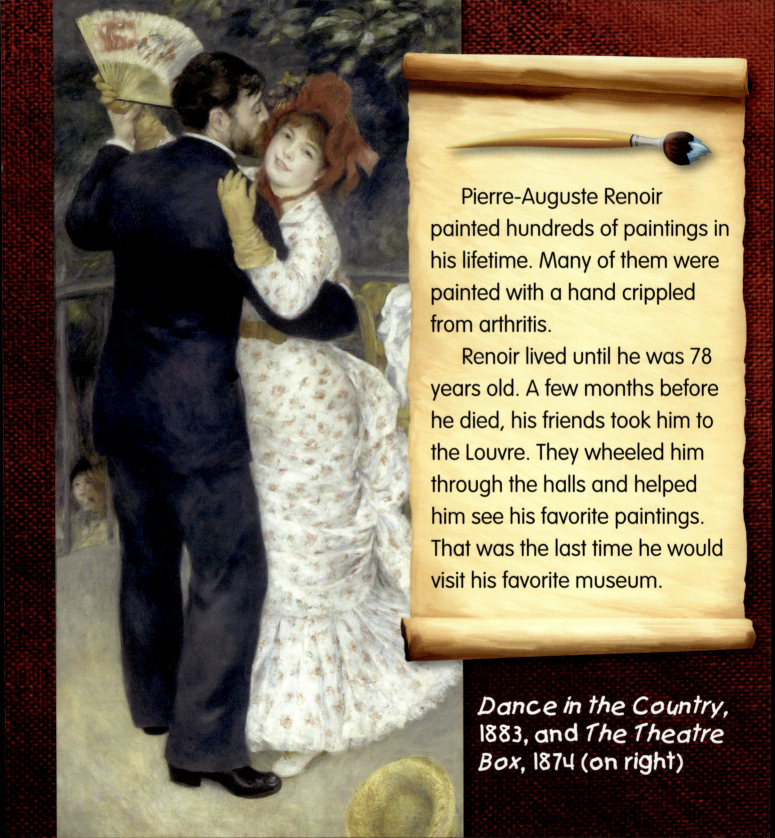

Pierre-Auguste Renoir painted hundreds of paintings in his lifetime. Many of them were painted with a hand crippled from arthritis.

Renoir lived until he was 78 years old. A few months before he died, his friends took him to the Louvre. They wheeled him through the halls and helped him see his favorite paintings. That was the last time he would visit his favorite museum.

Dance in the Country, 1883, and *The Theatre Box,* 1874 (on right)

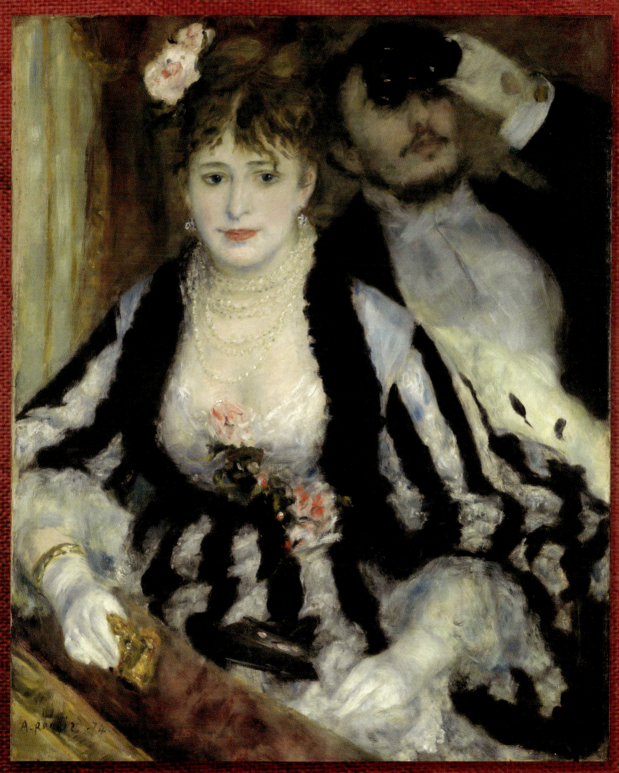

Timeline

1841 — Pierre-Auguste Renoir is born on February 25 in Limoges **(lih-MOHJ)**, France. He is the sixth of seven children of a tailor and a seamstress.

1844 — His family moves to Paris.

1854–1858 — Renoir is apprenticed as a porcelain painter. He decorates fans, dishes, and window shades.

1860 — He visits the Louvre museum often, and copies the artwork of the masters.

1862 — He takes art classes at the École des Beaux-Arts. He meets Claude Monet and Alfred Sisley. He paints in the forest of Fontainebleau.

1872 — He sells his first paintings to an art dealer (Paul Durand-Ruel).

1874 — Renoir organizes an art show with Monet, Cézanne, and Degas. Their artwork is given the name "impressionism."

1875–79 — Renoir sells a few paintings. He also gets paid to paint portraits of people.

1880 — He meets Aline Charigot. She is one of the many friends Renoir included in *Luncheon of the Boating Party*. He moves to Italy to study classical art.

1884 — Renoir's art begins to look less like impressionism and more like classical Italian art.

1890 — He marries Aline Charigot. They will have three sons together: Pierre, Jean, and Claude.

1897 — Doctors tell Renoir he has arthritis. The disease injures his joints so that he has to use a wheelchair. He cannot grip his brushes, so he has someone strap them to his hands. He moves to Cagnes-sur-Mer in the South of France, where the warmer climate will ease his joint pain.

1912 — Friends ask a doctor from Vienna to help Renoir walk again. Renoir finds that walking takes too much effort. He decides to stay in his wheelchair and use his energy to paint.

1919 — Renoir dies on December 3, at the age of 78.

Selected Works

Paintings

1869	La Grenouillére
1870	La Promenade
1870	A Road in Louveciennes
1872	Claude Monet Reading
1875	The Skiff
1875	The Grand Boulevards
1876	Dance at Le Moulin de la Galette
1879	Oarsmen at Chatou
1881	Luncheon of the Boating Party
1881	Pink and Blue
1881	Two Sisters (On the Terrace)
1883	Dance in the Country
1883	Children on the Seashore, Guernsey
1885	The Umbrellas
1885	Girl with a Hoop
1890	The Apple Seller
1892	Landscape at Pont-Aven
1893	Young Girls at the Piano
1905	Young Woman Arranging Her Earring
1908–1914	The Farm at Les Collettes, Cagnes
1918	Madeleine Leaning on Her Elbow with Flowers in Her Hair
1918–1919	The Concert
1919	Landscape

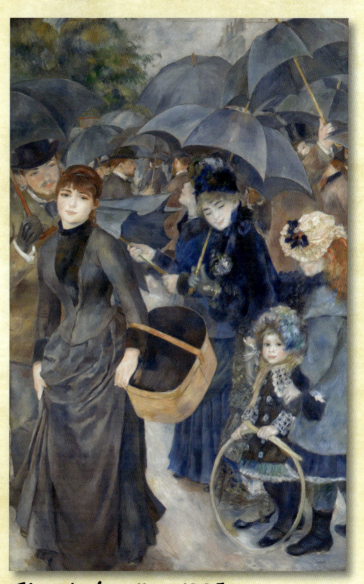

The Umbrellas, 1885

Further Reading

Works Consulted

Covington, Richard. "Renoir's Controversial Second Act." *Smithsonian*, February 2010. Retrieved July 26, 2016. http://www.smithsonianmag.com/arts-culture/renoirs-controversial-second-act-4941803/?no-ist

Goodbye-Art Academy. *Pierre-Auguste Renoir Biography*. Published March 17, 2014. Retrieved July 26, 2016. https://www.youtube.com/watch?v=hF_nArPfEgs

The Metropolitan Museum of Art: "Auguste Renoir (1841–1919)" http://www.metmuseum.org/toah/hd/augu/hd_augu.htm

Phillips Collection http://www.phillipscollection.org/collection/browse-the-collection?id=1637

Books

Cesar, Stanley. *Twenty-four Pierre-Auguste Renoir Paintings (Collection) for Kids.* Amazon Digital Services: Unlimited, 2014.

Deiss, Susanna. *Renoir: The Magic of Childhood*. CreateSpace Independent Publishing Platform, 2013.

Sellier, Marie. *Renoir's Colors*. New York: J. Paul Getty Museum, 2010.

On the Internet

Biography: "Pierre-Auguste Renoir" http://www.biography.com/people/pierre-auguste-renoir-20693609

The Metropolitan Museum of Art: "Auguste Renoir (1841–1919)" http://www.metmuseum.org/toah/hd/augu/hd_augu.htm

Glossary

apprentice (uh-PREN-tis)—A person who studies with an expert to learn a trade.

arthritis (arth-RY-tus)—A disease that causes pain in the joints of the body.

canvas (KAN-vus)—A sturdy fabric on which artists paint.

croissant (kruh-SAHNT)—A French roll that is buttery and flaky.

easel (EE-zul)—A stand or frame that holds an artist's canvas.

impressionism (im-PREH-shuh-nism)—A style of painting that uses bright colors and brush strokes to give an idea of an object, instead of its direct shape.

Louvre (LOOV)—A famous art museum in Paris, France.

madame (muh-DAHM)—The French word for "missus."

monsieur (mis-YUR)—The French word for "mister."

palette (PAL-it)—A wooden board on which an artist mixes paint.

porcelain (POR-suh-lin)—A hard, shiny white material that is used to make dishes and decorations.

Seine (SEHN)—A river that runs through Paris.

PHOTO CREDITS: All photos—Public Domain. Every measure has been taken to find all copyright holders of material used in this book. In the event any mistakes or omissions have happened within, attempts to correct them will be made in future editions of the book.

Index

apprentice 14
Argenteuil 20
arthritis 10, 26
Ball at the Moulin de la Galette 19
canvas 23
Cézanne, Paul 19
Charigot, Aline (wife) 5, 7, 14, 17, 20, 23
Children on the Seashore, Guernsey 22
croissants 17
Dance in the Country 26
Degas, Edgar 19
easel 25
Farm at Les Collettes, Cagnes, The 24–25
Louvre 14, 26
Luncheon of the Boating Party 4–5
Monet, Claude 14, 17, 20
Monet Painting in His Garden at Argenteuil 20

palette 10, 23
Paris 14, 17
Pont Neuf, The 16
porcelain 14
Renoir, Pierre-Auguste
 apprenticeship 14
 birth 28
 childhood 14
 education 14, 28
 friends 5, 19, 26
 porcelain painter 14
 studio 9–10, 17, 13, 23
 study at the Louvre 14, 26
 years in Paris 14, 17
Seine 17
Self-Portrait (1875) 8
Self-Portrait (1910) 11
Skiff, The 12–13
Theatre Box 26
Young Girls at the Piano 15